Let's Draw a
Dinosaur with Shapes

Joanne Randolph

Illustrations by Emily Muschinske

The Rosen Publishing Group's
PowerStart Press™
New York

For Joey

Published in 2005 by The Rosen Publishing Group, Inc.
29 East 21st Street, New York, NY 10010

First Edition

Book Design: Emily Muschinske

Photo Credits: p. 23 © Corbis/Royalty Free.

Library of Congress Cataloging-in-Publication Data

Randolph, Joanne.
Let's draw a dinosaur with shapes / Joanne Randolph.
 p. cm. — (Let's draw with shapes)
Summary: Offers simple instructions for using geometric figures to draw different kinds of dinosaurs.
ISBN 1-4042-2793-8 (Library Binding)
1. Dinosaurs in art—Juvenile literature. 2. Drawing—Technique—Juvenile literature. [1. Dinosaurs in art. 2. Geometry in art. 3. Drawing—Technique.] I. Title. II. Series.

NC780.5.R36 2005
743.6—dc22
 2003022453

Manufactured in the United States of America

Contents

Draw a red oval for the head of your dinosaur. Add a red rectangle for the neck.

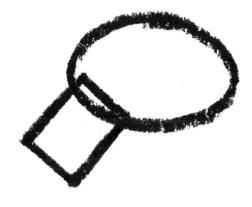

Add an orange oval for the body of your dinosaur. Draw an orange triangle for the tail.

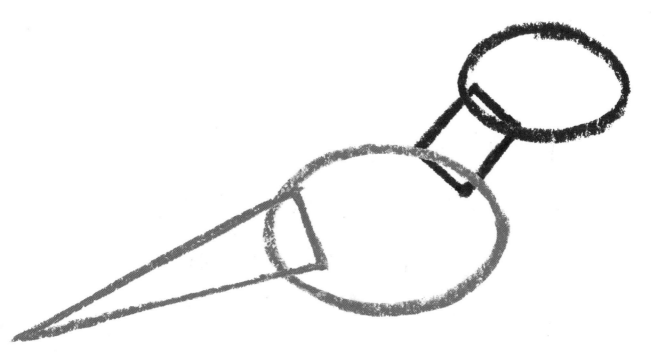

Draw two yellow rectangles
for the arms of your dinosaur.

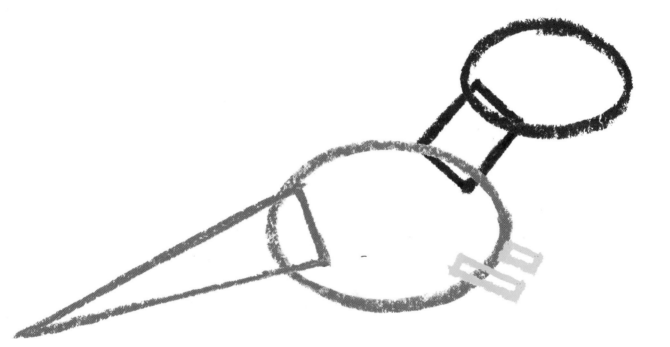

9

Add four green rectangles
for the legs of your
dinosaur.

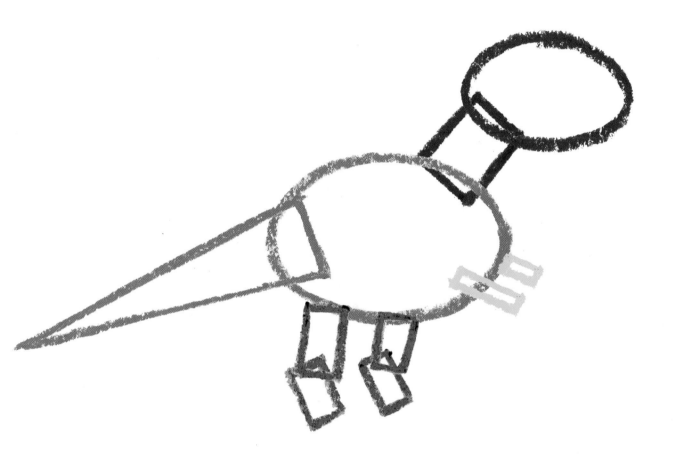

Draw two small blue triangles for the feet of your dinosaur.

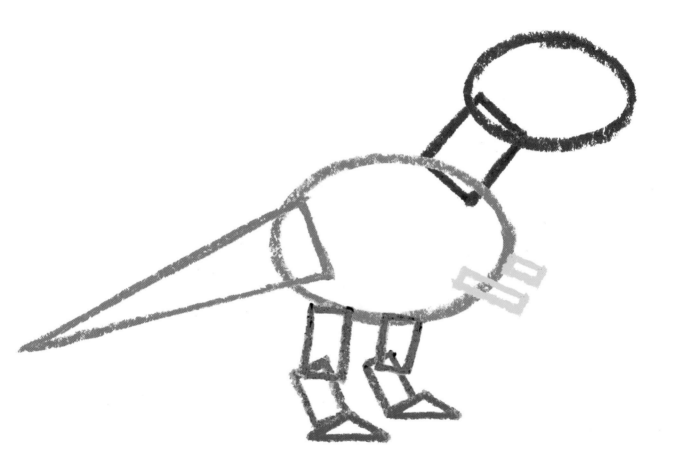

Add two purple half circles for the hands of your dinosaur.

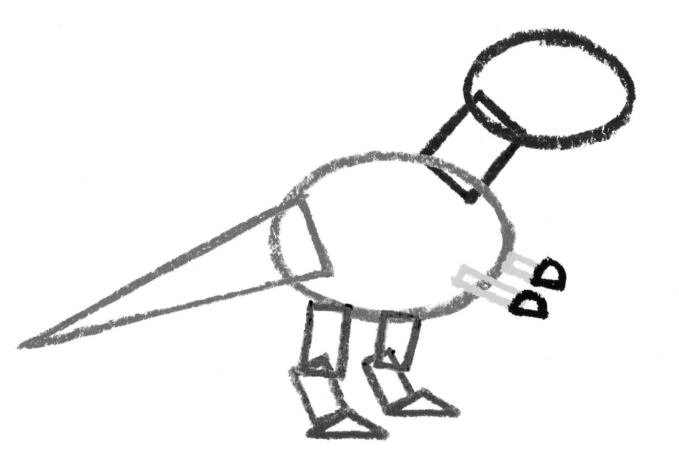

15

Draw a big pink triangle for the mouth of your dinosaur. Add six small pink triangles for teeth.

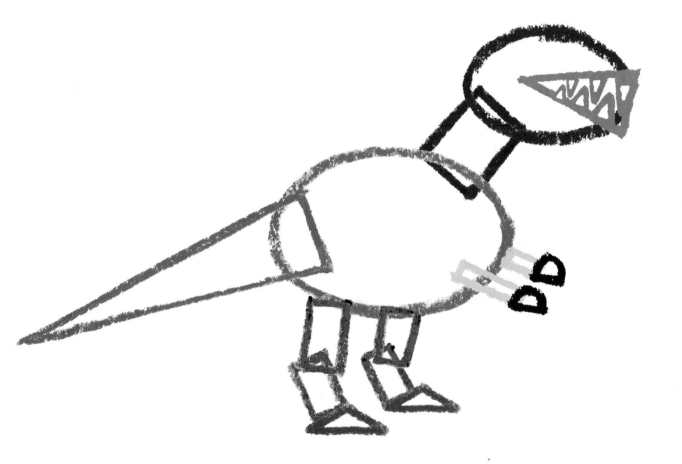

Add a black half circle and a small black circle for the eye of your dinosaur.

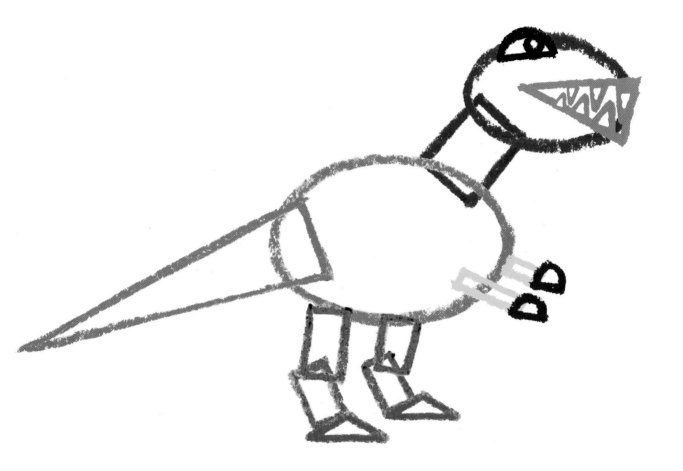

Color in your dinosaur.

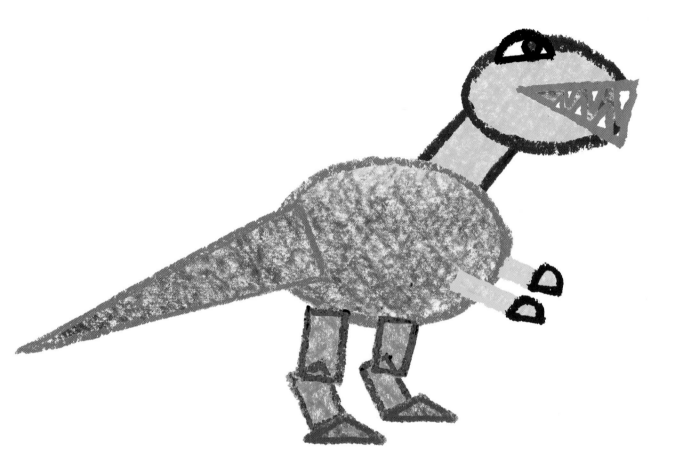

This dinosaur is a
Tyrannosaurus rex.

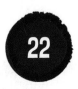

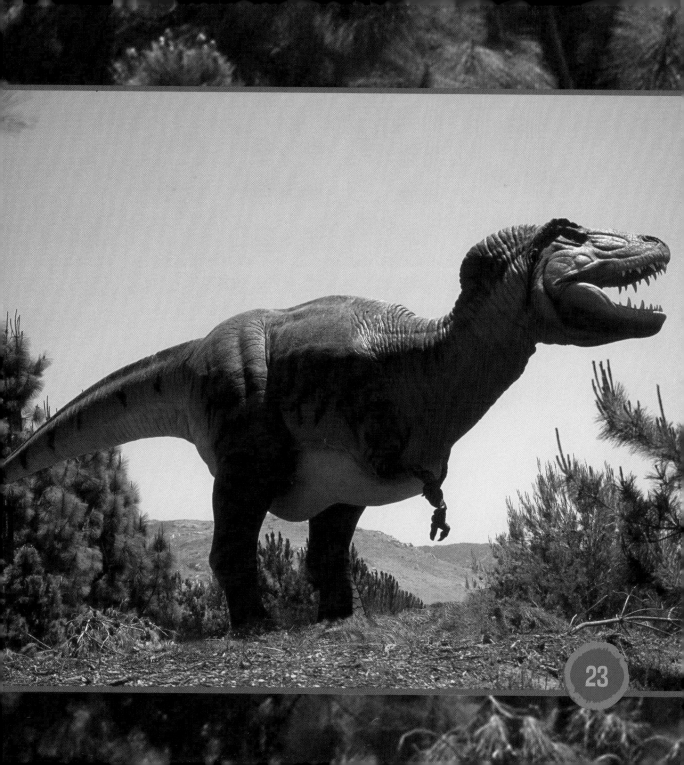

Words to Know

mouth

neck

tail

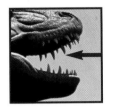
teeth

Colors

red

orange

yellow

green

blue

purple

pink

black

Shapes

○ circle

□ square

△ triangle

▭ rectangle

⬭ oval

⌓ half circle

Index

Web Sites

Due to the changing nature of Internet links, PowerStart Press has developed an online list of Web sites related to the subject of this book. This site is updated regularly. Please use this link to access the list:

www.powerkidslinks.com/lds/drawdino/